TRADITIONAL
COOKING

TUSCANY

FAVOURITE RECIPES

SIME BOOKS

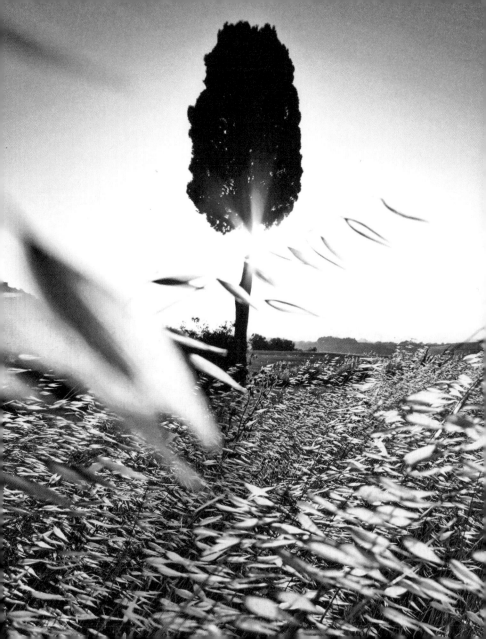

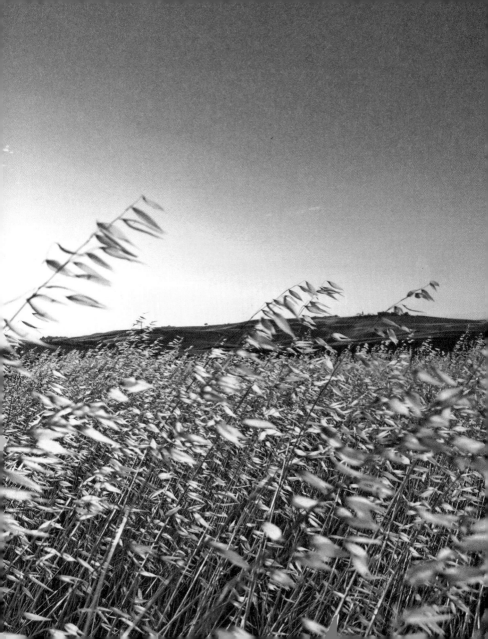

CONTENTS

Recipe difficulty:

■ ◻ ◻ easy

■ ■ ◻ medium

■ ■ ■ hard

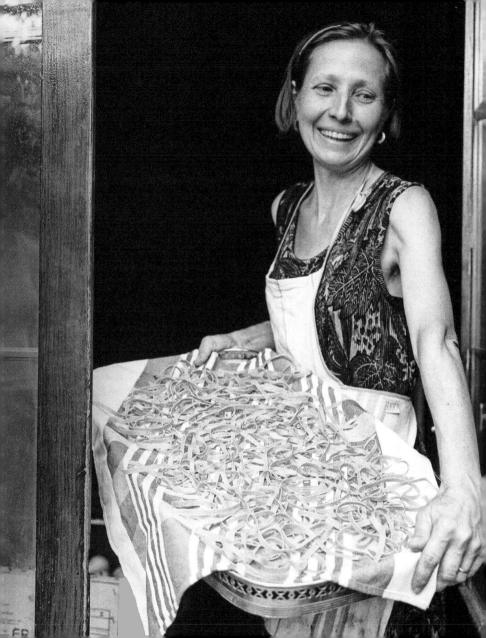

THE FLAVOURS OF TUSCANY

Pellegrino Artusi had this to say about his Tuscan passion for vegetables: "The Tuscans, the Florentines in particular, are so fond of vegetables that they would forsake all else for them." Yet this strong, forthright cuisine is popularly perceived as synonymous with those meat dishes for which the Tuscans have a genuine affection: cibreo made from chicken giblets, lampredotto or reed tripe, honeycomb tripe, Chianina and Maremma beef, Cinta Senese pork, game... In actual fact, Artusi was quite right and indeed confirms a culinary panorama of extraordinary complexity and richness, dating back to the times of the Etruscans, the ancestors of today's Florentines. Dishes from that bygone era still grace the table and include spelt soup, and the use of pulses like lentils, fava beans, and chickpeas (beans arrived later, after the discovery of America). The Romans inherited this rich culinary heritage and merged it with their own traditions. During the Middle Ages other dishes developed, like ribollita, panzanella, panforte, all based on bread, an almost sacred food in Tuscany, and used in an infinity of ways, haughtily without salt, as even Dante takes the trouble to recall in his *Paradise*. Thanks to the central role played by Pisa in international trade, the

use of spices became widespread and is still very much alive.Between the 14th and 16th centuries, during the splendid Florentine Renaissance, Tuscan cuisine was extensively enriched with recipes and raw materials, even exporting famous dishes and etiquette to France. The names of Catherine de' Medici, married to Henry II, and Mary, wife of Henry IV, are enough to evoke the splendor of a court where cuisine was foremost and key in entertainment. Festivities and lavish banquets stunned visitors thanks to the vivacious inventions of the Medici cooks.

The great culinary tradition did not end with the Medicis and in later centuries was encoded and upgraded up to the present day and its precise consideration as one of the most classic of Italian regional cuisines, emblematic of a deep-rooted local spirit.

The geographical layout has undoubtedly contributed to the variety of raw materials and dishes, and to the differentiation between meat and fish cuisine. The whole of Tuscany is a mosaic of local traditions, often interwoven with exchanges with neighboring regions. For instance, the coast cuisine of Versilia (on the border with Liguria) differs significantly from that of Livorno and

Maremma. The Apennine mountains, shrouded in their chestnut groves, provide the raw material for many recipes. Plains and hills constitute the ideal environment for the massive olive and vine cultivation, transformed into rivers of oil and wine that "flood" tables worldwide. For stock rearing Maremma presents a scenario of another era, with its *butteri* cowboys herding cattle.

Tuscan cuisine can be simple and refined, or aristocratic and rustic, but it is always genuine and tasty, and that also applies to its delicious sweets, where memories of the past often echo of those Middle Ages when Florence and Tuscany really were at the center of world affairs.

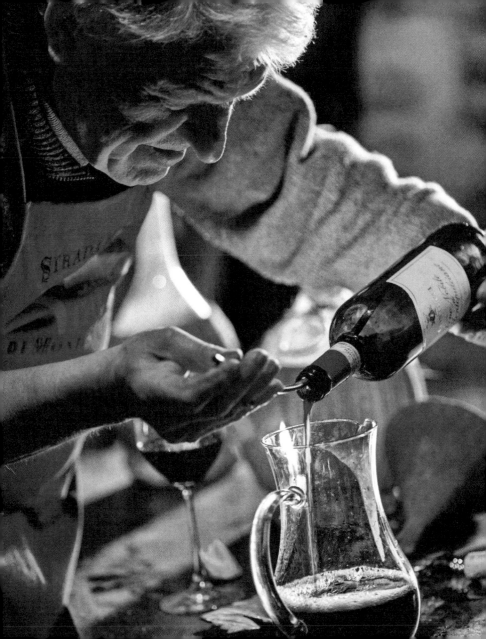

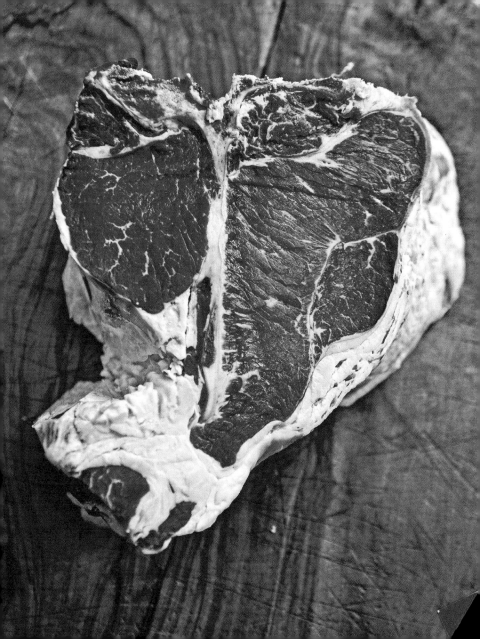

ANTIPASTOS

Serves four
- 400 g (14 oz) stale homestyle bread
- 4 ripe salad tomatoes
- 2 red onions
- 2 cucumbers
- a few basil leaves
- extra virgin olive oil
- red wine vinegar
- salt

PANZANELLA

Leave the bread to soak in cold water for about 20 minutes.

When soft, pick it up a little at a time and squeeze gently until all the bread is dry.

Place the bread in a tureen, sprinkle with salt and add all of the vegetables, thinly sliced, and torn basil leaves.

Season with salt and oil, stir and refrigerate.

When serving, add vinegar and garnish with a few basil leaves.

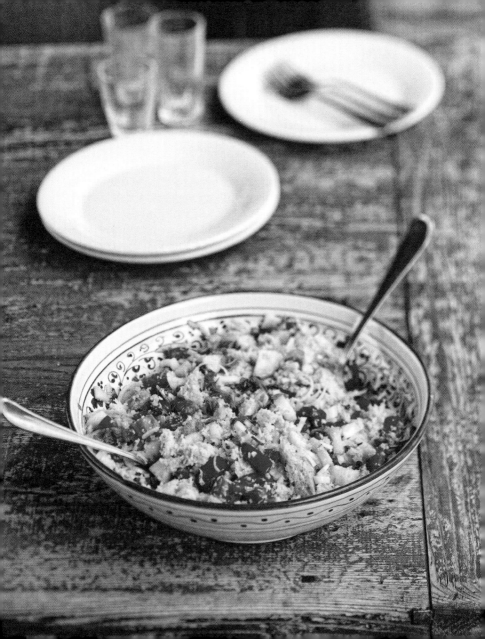

TUSCAN BLACK CROSTINI

■ ▢ ▢

Serves six
- Tuscan bread a couple of days old
- 400 g (14 oz) of chicken livers
- 1 clove of garlic
- 1 small red onion
- a few sage leaves
- 100 ml (½ cup) of Vin Santo or white wine
- 1 tsp of anchovy paste (to taste)
- 60 g (2 oz) capers (dried if pickled)
- juice of half a small lemon
- vegetable or chicken broth
- extra virgin olive oil
- salt
- pepper

Put oil, garlic, sliced onion, livers, sage, salt and pepper in a covered skillet and cook slowly over a low heat for 15–20 minutes. Stir occasionally.

When done, chop with a knife. Return to the skillet over a low heat until it begins to stick slightly, then add the Vin Santo or white wine, and cook for 5 more minutes.

Chop the capers in a mixer and add to the mixture along with the anchovy paste (to taste), and leave to cook for another 3 minutes.

Squeeze in the lemon and cook for a further 2 minutes. If the mixture is too thick, add a little hot broth.

Slice the bread and dampen with the warm broth, then coat the surface with a layer of salsa.

Serve at room temperature.

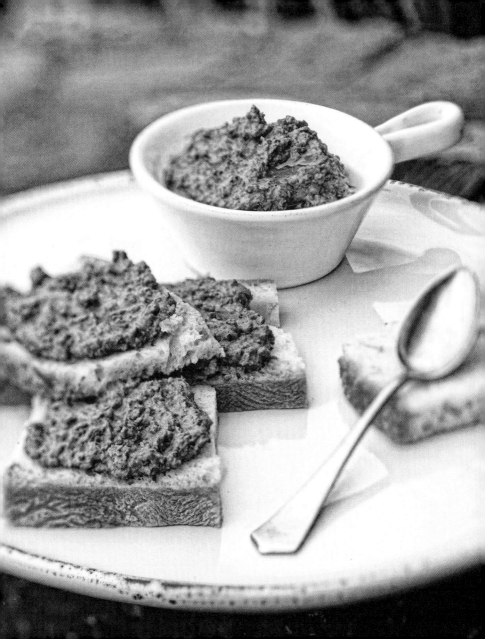

TUSCAN FOCACCIA

Serves six
- 900 g (2 lbs) of allpurpose white flour
- 0.5 l (1 pint) warm water
- 25 g (1 oz) fresh baker's yeast or 12 g (1 pinch) of dry yeast
- 1/2 level tsp of sugar
- 1 tbsp of salt
- 10 tbsps of extra virgin olive oil
- rosemary
- extra virgin olive oil and coarse salt for cooking

Pour 7 tbsps of water into a small bowl with the yeast and sugar. Leave until the ingredients froth.

Mix the flour in a large bowl with salt, then add the yeast, oil and warm (not hot) water, and mix thoroughly. To make a softer focaccia replace the oil with 3 tbsps of lard. Add more water if necessary: the dough should be quite soft and sticky.

Let the dough rise under a damp cloth for about 90 minutes, in a warm place.

When it has risen, brush a baking sheet with oil, flour hands well and stretch the dough to a height of approximately 1.5 cm (2/3 in). Use fingertips to make the characteristic "dimples" in the focaccia, brush with plenty of oil and sprinkle with salt. Dust with rosemary to taste.

Bake for about 25 minutes in an oven preheated to 180 °C (355 °F).

BRUSCHETTA WITH PORCINI MUSHROOMS AND GARLIC BREAD

Serves four
- 8 slices of homestyle bread
- 4 fresh porcini mushrooms
- 2 cloves of garlic
- 1 tbsp of chopped parsley
- white wine
- extra virgin olive oil
- chilli pepper
- salt
- pepper

Clean the mushrooms with a kitchen towel, without washing, and slice lengthwise.

Heat oil in a skillet with a clove of chopped garlic, add the mushrooms, parsley, salt, and a pinch of chilli; cook on medium heat for about 10 minutes. Add half a glass of wine and allow to evaporate.

Grill the bread, rub the clove of garlic on each slice, place on a tray and add, in this order, salt, pepper, plenty of oil for the fettunta (greased slice).

Brush oil lightly on the other slices, to be served with porcini sauce topping.

Serve hot.

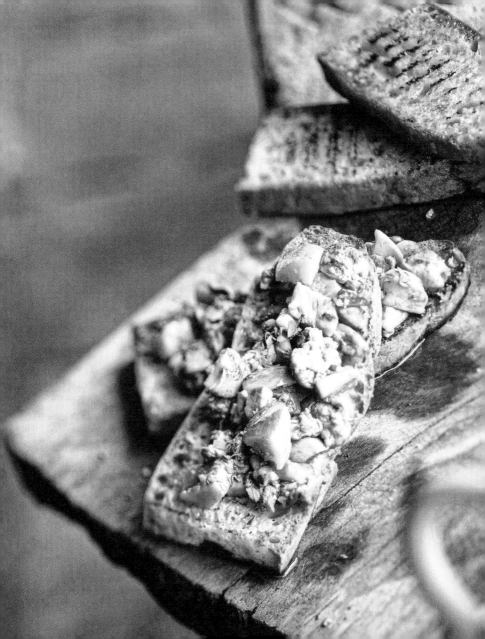

CECINA CHICKPEA FLOUR BREAD

Serves four
- 125 g (5 oz) chickpea flour
- 0.5 l (1 pint) warm water
- 1 sprig of rosemary
- extra virgin olive oil
- coarse and fine salt
- pepper

Pour the flour into a bowl and slowly pour in the water, whisking briskly to remove lumps, add a pinch of fine salt and two tbsps of oil, over and leave for at least 2 hours.

Preheat the oven to 250° C (480 °F), grease a pizza tray and pour in the mixture, which should not be more than 0.5 cm ($^1/_{10}$") deep, sprinkle with rosemary and bake for about 30 minutes until golden brown.

Remove from the oven when still warm and sprinkle with coarse salt and plenty of black pepper.

If preferred, add finely chopped soft paste cheese like Pecorino or Colonnata lard.

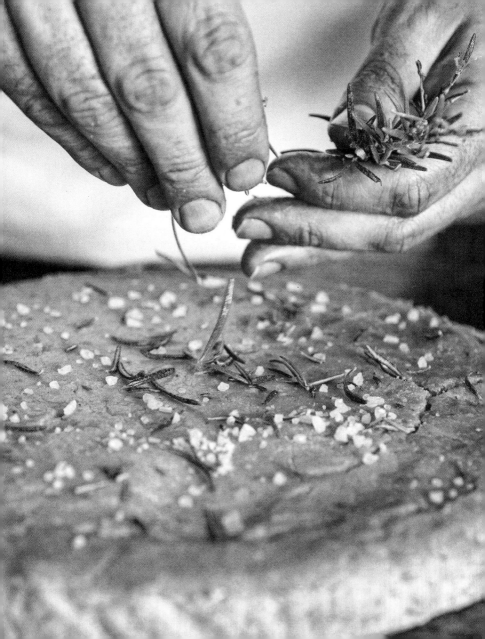

FIRST COURSES

ACQUACOTTA

■ ◻ ◻

Serves four
- 400 g (14 oz) porcini mushrooms
- 80 g (3 oz) tinned tomatoes
- 2 eggs
- 2 tbsps of Parmigiano Reggiano
- a few calamint leaves
- 1 clove of garlic
- extra virgin olive oil
- salt
- pepper
- slices of toasted bread

Clean and slice the mushrooms. Fry in a skillet with oil and a clove of garlic; add the calamint, season with salt and pepper.

Add the tomato and allow to dry, leaving to stand for a few minutes.

Pour in a ladleful of hot water per person, cover and allow to simmer for about 15 minutes.

Whisk raw eggs with Parmigiano Reggiano in a tureen. Continue whisking the mixture and pour in the mushroom soup to make a cream.

Cover the tureen and leave to sweat for 4-5 minutes.

Serve, but not too hot, in bowls with a slice of toasted bread.

PAPPA AL POMODORO

■ ☐ ☐

Serves four
- 300 g (10 oz) of homestyle bread
- 500 g (1 lb) of ripe tomatoes
- 1 l (2 pints) of broth
- 3 cloves of garlic
- chilli pepper
- a few basil leaves
- extra virgin olive oil
- salt
- pepper

Sauté the peeled, crushed garlic cloves in a pan with 6 tablespoons of oil, ensuring they do not burn; add a hint of chilli and the previously peeled and chopped tomatoes; add the basil.

Bring to the boil and after few minutes, add all the broth.

Season with salt and return to the boil, then add the bread in thin slices.
Cook for 15 minutes.

Remove the pan from the heat and leave covered for about an hour.

Before serving, stir carefully and drizzle with a little oil, then dust with pepper.

FLORENTINE-STYLE CREPES

Serves four
For the crepes:
- 100 g (4 oz) of flour
- 2 eggs
- 250 ml (1 cup)
 of milk
- 50 g (2 oz) of butter
- salt
For the filling:
- 300 g (10 oz)
 of spinach
- 300 g (10 oz)
 of ricotta
- 1 egg
- nutmeg
- salt
- pepper
For the condiment:
- 50 g (½ cup)
 of flour
- 50 g (2 oz) of butter
- 0.5 l (1 pint) of milk
- 3 tbsps of tomato
 sauce
- nutmeg
- salt
- pepper

Boil the spinach, squeeze dry and chop finely, then place in a souptureen; combine all other ingredients for the filling, mixing with care.

Prepare the batter by mixing the flour, eggs and salt, then slowly add the milk and the melted butter. Mix thoroughly and let stand for half an hour.

In a nonstick skillet, cook 8 crepes in a little melted butter.

Fill with the mixture, fold in half and then in half again.

Prepare the béchamel by melting the butter in a saucepan, adding the flour and stirring on a low heat for 3–4 minutes. Add the milk at room temperature and continue to stir; bring to the boil, stirring occasionally.

Season with a pinch of salt, a pepper and grated nutmeg. When the sauce comes to the boil, simmer on a low heat for 10 minutes.

Grease a baking dish with a little butter, arrange the crepes, cover with béchamel sauce and drizzle with a little tomato sauce.

Cook in the oven at 180 °C (355 °F) for about 20 minutes until brown.

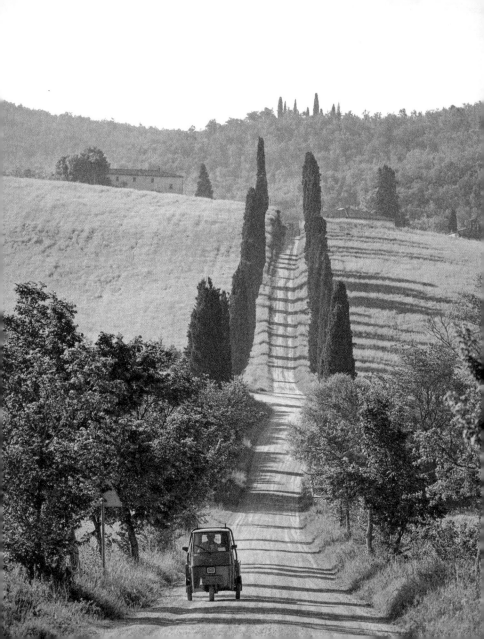

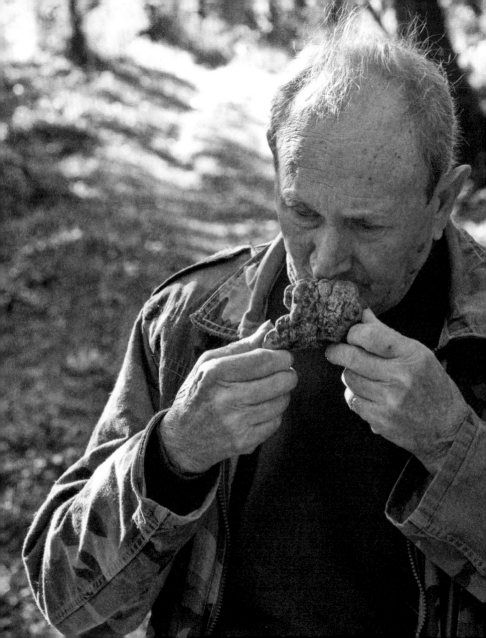

Serves four
For the pici pasta:
- 500 g (5 cups) of strong wheat flour
- 250 g (½ pint) of water
- extra virgin olive oil
- salt

For the sauce:
- 500 g (1 lb) of fresh tomatoes
- 6–8 cloves of garlic
- chilli pepper
- extra virgin olive oil
- salt
- pepper

PICI PASTA WITH AGLIONE SAUCE

How to prepare the pici pasta

Make a well of flour on a pastry board, add salt and pour in lukewarm water a little at a time.

Knead at length, add a tsp of olive oil, and continue to work with hands until the dough is firm, smooth free of limps, adding water or flour if necessary.

Leave for 30 minutes then roll out the dough to a thickness of 1 cm (²/₅") with a rolling pin, grease with oil and cut into strips as wide as they are thick.

Sprinkle the work surface with flour and with the right palm rub and roll up each strip while the left hand gently stretches each strip into long, spaghetti that are quite thin and of a similar diameter. Dust with flour to stop the pasta sticking.

Cook for about 6 minutes in plenty of boiling salted water.

How to prepare the sauce
Remove the garlic skin and the central shoot, then fry gently for 8–10 minutes in plenty of oil in a skillet where the pici pasta will be tossed. Turn to stop the garlic becoming too dark.

When the cloves have softened, crush with a fork, add chopped tomatoes and chilli peppers, and leave to stand for 15 minutes, stirring occasionally, and seasoning with salt and pepper.

When the pici are cooked, toss in the sauce and serve as preferred with mature Pratomagno Pecorino.

■ ■ ◻

Serves four
- 100 g (4 oz)
 of chickpeas
- 100 g (4 oz)
 of beans
- 100 g (4 oz) dried
 corn
- 120 g (5 oz) dried
 chestnuts
- 1 white onion
- 1 stalk of celery
- 1 carrot
- 2 cloves of garlic
- parsley
- sage
- 60 g (2 oz) of
 Rigatino pancetta
- 500 g (1 lb)
 tomatoes
- stale Tuscan bread
- extra virgin olive oil
- salt

VALDICHIANA CECIGLIANO CHICKPEA STEW

Soak the chickpeas, beans, corn and chestnuts overnight.

Boil separately with a dash of salt until *al dente*.

Chop the herbs with the parsley, garlic, sage, and pancetta, and sauté with 8 tbsps of olive oil in a large saucepan.

Leave to dry and add the chopped tomatoes, cooking for 15 minutes, then add the pulses and chestnuts, and 750 ml (1 pints) of hot water.

Simmer over a low heat until the pulses are fully cooked but still firm, not crumbly.

Season with salt and serve with toasted stale bread, drizzled with oil.

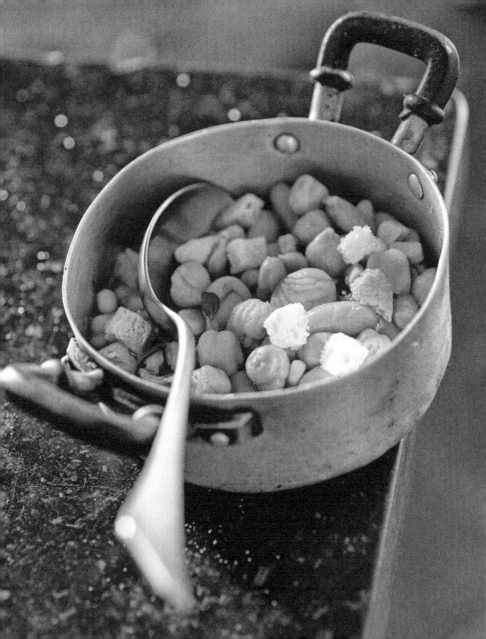

■ ■ ▢

Serves four
- 400 g (14 oz) of
 egg pappardelle
- 500 g (1 lb) of lean
 boar
- 300 g (10 oz)
 of whole tinned
tomatoes
- meat stock
- 3 cloves of garlic
- parsley
- sage
- rosemary
- juniper berries
- extra virgin olive oil
- salt
- pepper
For the marinade:
- 1 stalk of celery
- 1 carrot
- 1 onion
- 1 tsp of black
 peppercorns
- 1 tsp juniper berries
- plenty of red wine

PAPPARDELLE PASTA
WITH BOAR SAUCE

Marinade
The meat should never be washed with water
either before or after marinating, but red wine
vinegar may be used.

Place the boar joint in a large bowl, add all the
chopped herbs and crushed juniper berries,
then cover with red wine.

The length of time required for the marinade
depends on the age of the boars, so it may
vary from 12 to 24 hours.

When complete, cut the meat into small
pieces and carefully remove any fat (but keep
aside about a quarter), bones and gristle; keep
aside both the herbs and the wine.

How to make the sauce
If possible, prepare the sauce in advance and
leave to stand overnight.

Pour 4 tbsps of oil into a preheated skillet
large enough to hold the meat, sear then
brown for 15 minutes or so, until it has
released all its juices.

Tip the meat into a colander and leave
to drain.

Meanwhile chop the marinade herbs finely with garlic and sauté for a few minutes in a pan with 4 tbsps of olive oil.

Add the well-drained meat and fry for another 5 minutes on a high heat, then cover with wine. When the wine has evaporated, add the crushed or pureed tomatoes, the chopped herbs, another tbsp of crushed juniper berries and another tsp of black pepper; simmer for at least an hour (longer if the meat was from an adult boar), stirring and adding hot broth if it dries too much. Season with salt.

Cook the pappardelle in plenty of salted water and toss the pasta in the sauce. If it appears too dry, add some of the pasta water; add cheese to taste.

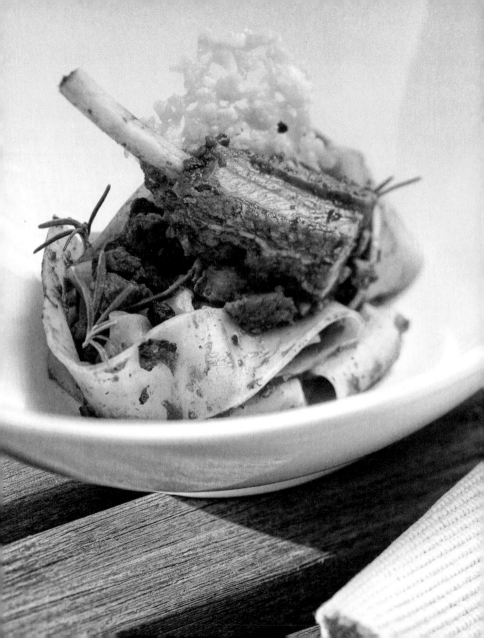

RIBOLLITA TOSCANA

Serves four
- 300 g (10 oz) of
 dry cannellini beans
- 1 black cabbage
- ½ savoy cabbage
- 1 bunch of chard
- 3 ripe tomatoes
- 2 stalks of celery
- 2 carrots
- 1 onion
- 1 leek
- 2 cloves of garlic
- 2 sprigs of thyme
- 400 g (14 oz) of
 stale bread
- extra virgin olive oil
- salt
- pepper

Cook the beans and retain all their water.
Blend about , pouring the puree directly
back into the water, and keep the others aside.

Sauté the chopped onion and leek in oil, add
all vegetables cut into pieces, leave to flavour,
then add the tomatoes, thyme, salt and
pepper.

Pour all the bean liquid into the pan with
the vegetables and cook the soup slowly
for another hour, adding a little hot water if
necessary. When almost done, add the whole
beans that were kept aside.

Line the bottom of a soup tureen with slices
of bread and cover with a generous layer of
boiling soup; proceed with another layer of
bread and one of soup until the ingredients
have been used up. Leave to cool.

The following day the soup should be
recooked for a few minutes, directly in a
skillet. Drizzle with oil, dust with pepper and
serve.

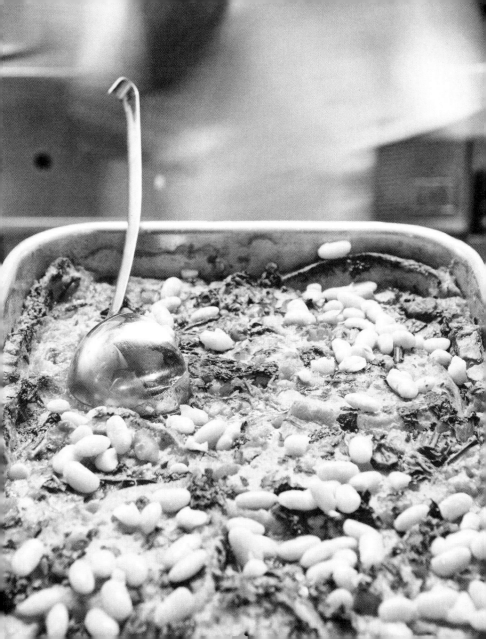

■ ■ ◻

Serves four
For the sauce:
- 300 g (10 oz) of minced (ground) veal and pork
- 2 fresh Tuscan sausages
- 20 g (1 oz) of Rigatino pancetta
- 600 g (21 oz) tinned tomatoes
- 1 onion
- 1 carrot
- 2 stalks of celery
- 2 cloves of garlic
- 5 basil leaves
- 0.5 l (1 pint) of Sangiovese wine
- 0.5 l (1 pint) of beef stock
- nutmeg
- extra virgin olive oil
- salt
- pepper

POLENTA WITH TUSCAN SAUCE

How to make the sauce
Prepare a fine mirepoix with the herbs, garlic and Rigatino, and fry on a low heat for 15 minutes with 2 tbsps of oil, making sure it does not stick or burn.

Add the minced (ground) meat and skinned sausages mashed with a fork, frying over high heat, then lowering the heat and cooking for 20 minutes.

In different areas of Tuscany chicken livers (about 100 g or 4 oz) are added, while in the Tuscan-Romagna Apennines fresh or dried porcini mushrooms (about 20 g or 1 oz) rehydrated in boiling milk, are another ingredient.

Add the wine and deglaze until it has dried completely, then add the tomatoes, of the stock, and the nutmeg; simmer for at least one hour, turning occasionally and adding stock if needed.

Lastly, add salt and pepper to taste, as well as the basil leaves scissored directly into the pan.

Serves four

For the polenta:
- 5 heaped tbsps
 of cornmeal
- 1 l (2 pints)
 of water
- 2 bay leaves
- 1 tbsp of extra
 virgin olive oil
- coarse salt

How to make the polenta

Boil the bay leaves in salted water with a drizzle of olive oil, sprinkle in the flour, whisking steadily, then stir with a wooden spoon until the pan comes to the boil; lower the heat and cook for 30 minutes, stirring frequently.

Pour the polenta into the plates and dress with the sauce.

SECOND COURSES

Serves six
- 800 g (2 lbs)
 of salt cod
- 400 g (14 oz) of ripe
 or tinned tomatoes
- 3 cloves of garlic
- 1 sprig of rosemary
- flour
- extra virgin olive oil
- salt
- pepper

FLORENTINE SALT COD WITH POLENTA

Dried salt cod must be left to soak in cold water in a refrigerator for at least 24 hours, changing the water often.

Chop the garlic and sauté the fresh diced or tinned tomatoes in a skillet over a low heat with 5–6 tbsps of oil and the sprig of rosemary. Cover and cook for about 15 minutes, ensuring the sauce does not dry out and adding half a glass of hot water is needed.

Trim and bone the cod, and cut into smallish pieces, dredge in flour and fry in hot oil starting on the skin side then turning to brown all over.

When brown, remove the cod and place quickly on kitchen paper to drain, then place in the tomato sauce. Cook for another 10 minutes, turning at least once very gently, season with salt and pepper to taste.

Serve the cod piping hot with slices of polenta (*see recipe page 45*).

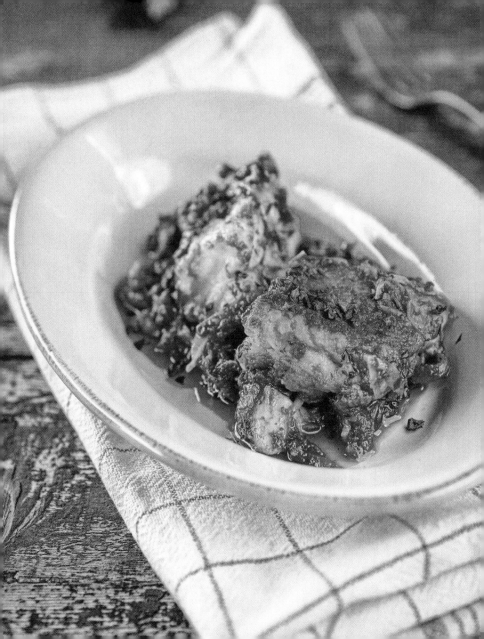

Serves six
- 1 clean, washed guinea fowl
- 400 g (14 oz) fresh porcini (or 60 g/2 oz of dried mushrooms)
- 1 medium red onion
- 1 tbsp of chopped garlic
- a handful of sage leaves
- 1 tsp of chopped parsley
- Vin Santo or dry Marsala
- extra virgin olive oil
- salt
- pepper

GUINEA FOWL IN VIN SANTO WITH PORCINI MUSHROOMS

Chop the onion and sage, and fry in a skillet with olive oil.

Cut the guinea fowl into mediumsized pieces and place in the skillet, seasoning with salt and pepper. Fry at medium heat until golden.

When the bottom of the pan begins to be too dry, pour a glass of Vin Santo or Marsala, and continue to cook for another 40 minutes, adding more wine if required.

Clean and chop the mushrooms.

Brown the garlic in a skillet with oil, then add the mushrooms and parsley, and cook for 5 minutes.

Add the mushrooms to the guinea fowl, stir and cook for another 5 minutes.

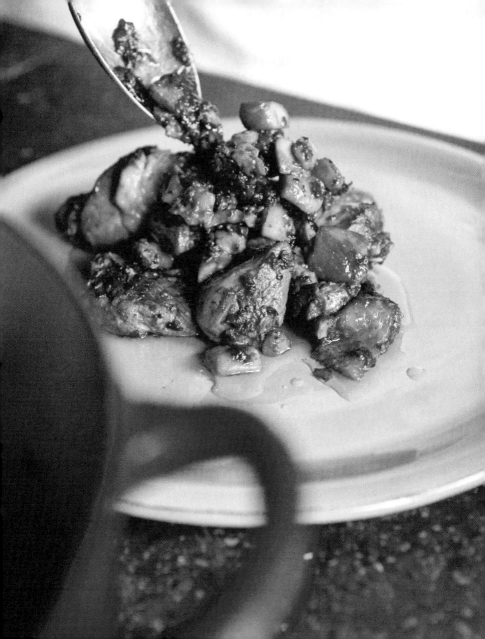

FLORENTINE "TAGLIATA" STEAK WITH GREEN PEPPER AND ROSEMARY

Serves six
- 1.2 kg (2½ lbs) steak
- aromatic salt (mix of sage, garlic, rosemary, and coarse salt chopped together)
- rosemary
- extra virgin olive oil
- green pepper

Heat a grill to a high temperature without oil.

Grill the steak for about 7 minutes on both sides.

When the steak comes away easily from the grill, turn over and season the cooked side with aromatic salt.

Meanwhile heat the oil with green pepper and rosemary, without frying.

When done, bone the steak with a good knife and cut the meat diagonally into slices.

Spoon the rosemary, green pepper and oil mixture on the meat placed on a warmed plate.

Garnish with lettuce and lemon, and serve immediately.

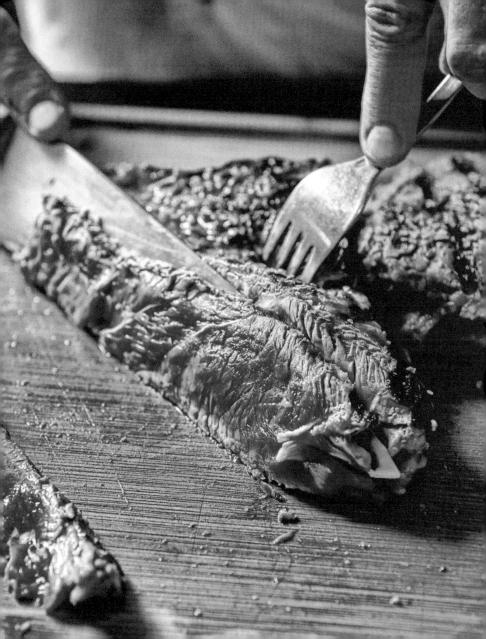

Serves six
- 1 kg (2 lbs) wild
 boar
- 2 stalks of celery
- 2 carrots
- 2 red onions
- 2 cloves of garlic
- 1 lemon
- rosemary
- a few sage leaves
- 4–5 bay leaves
- 1 tsp juniper berries
- 200 ml (1 cup) of
 good red wine +
 wine for the
 marinade
- 3 tbsps of red
 vinegar
- vegetable or meat
 stock
- a pinch of chilli
 powder
- extra virgin olive oil
- salt

STEWED BOAR

Cut the boar into pieces and place in a large
container with sage, 1 chopped stalk of
celery and 1 chopped carrot, 1 lemon cut into
quarters and squeezed, vinegar, rosemary,
chopped onion, garlic. Cover with red wine
and leave to marinate for 8 hours in a cool
place. At the end of this time, wash and dry all
the ingredients.

Chop the marinade vegetables and all the
others (carrot, celery and onion), put in a tall
saucepan with oil and cook for 10 minutes until
golden brown.

Add the meat and cook, then season with salt.
Deglaze with red wine and leave to reduce.

Add the juniper berries, bay leaves, chilli,
and enough broth to cover all the ingredients,
then cook covered over a low heat for about
2 hours, stirring occasionally. Add water or
stock if necessary, but leave to reduce fully
during the last 10 minutes.

Serve with polenta (*see recipe page 45*).

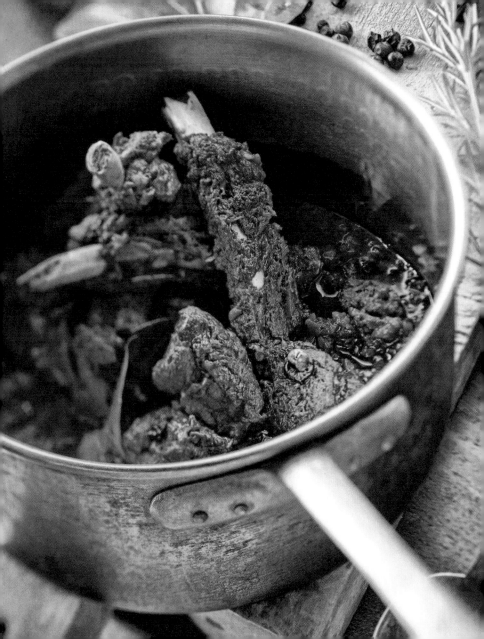

PORCHETTA-STYLE PORK SHANK WITH "PULEZZE"

Serves four
- 2 pork shanks
- 800 g (28 oz) turnip greens ("pulezze")
- 6 cloves of garlic
- 1 tbsp of wild fennel flowers
- 80 g (3 oz) of Rigatino pancetta
- 1 double malt (preferably spelt) beer
- 1 chilli pepper
- extra virgin olive oil
- salt
- 1 tsp of crushed peppercorns

Prepare a mirepoix of Rigatino pancetta, 4 cloves of garlic, fennel flowers, and pepper.

Incise between the muscles along the length of the shanks to create pockets, add salt and fill with the mirepoix. Rub mirepoix around the exterior of the shank also.

In a heated skillet fry the shanks well in oil, deglaze with the beer and leave to reduce for several minutes, then transfer to a baking tray. Pour the juices over the shanks then roast in a preheated oven at 140 °C (285 °F) for 45 minutes.

Add 2 tbsps of oil to the same skillet, along with the remaining garlic and a piece of chilli pepper. When the garlic begins to brown, add the turnip greens and sauté, add a ladle of water, cover and cook for 20 minutes, seasoning with salt.

Slice the shanks like a joint of beef, dress with the gravy and serve with the turnip greens.

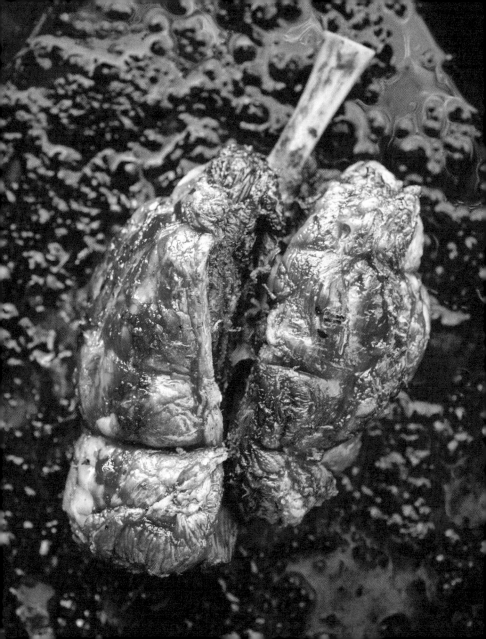

CHIANINA TARTARE

■ ■ ◻

Serves six
- 950 g (2 lbs)
 Chianina beef filet
- 2 chopped spring
 onions
- 2 tbsps salted
 capers
- 2 tbsps of chopped
 parsley
- 2 tbsps lemon juice
- 6 egg yolks
- 4 tbsps of extra
virgin olive oil
- 4 tbsps of brandy
- salt
- pepper

Chop the meat by knife tip.

Soak the capers, rinse well and chop finely.

Season the meat with the salt and pepper,
add the lemon juice, brandy and oil, mixing
well, then add the spring onions, capers and
parsley. Add mustard or Worcestershire sauce
to taste.

Divide the mixture into 6 portions and with a
round mould make a disk in the centre of each
plate.

With a spoon make a well in the centre
of each disk and add an egg yolk.

Remove the mould and serve.

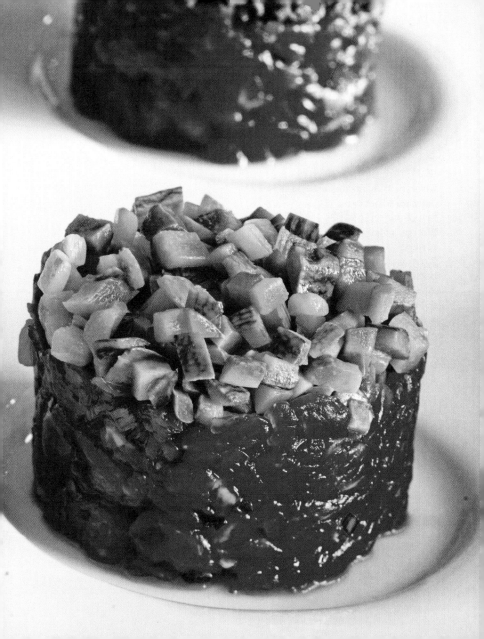

LIVORNO CACCIUCCO

Serves four
- 600 g (21 oz) of fish with bones (tub gurnard, red and black scorpionfish, seabream, spotted weever, Atlantic stargazer)
- 700 g (1 lbs) fish steaks (common smooth-hound, conger eel, moray eel, mullet, hake)
- 1 kg (2 lbs) shellfish
- 6 squill
- 500 g (1 lb) ripe or tinned tomatoes
- 1 onion
- 1 carrot
- 1 stalk of celery
- 2 cloves of garlic
- parsley
- chilli pepper as required
- ½ glass of white wine
- home-style bread
- extra virgin olive oil
- salt

Scale, gut and trim bones and fins from the whole fish. Slice and cube fish steaks. Clean the shellfish. Wash and dry all the seafood.

Coarsely chop the herbs and sauté in oil, add the chilli peppers, then the shellfish, allow to flavour and drizzle with wine.

After about 10 minutes, remove from the skillet, add the tomatoes and all the fish with bones, add salt and cook for about 15 minutes.

Remove the fish from the heat and blend, including the bones.

Pour the purée back into the skillet used for cooking, dilute with water so it is not too thick, then add the fish steaks. Cook for about 20 minutes.

Add the shellfish cooked earlier and continue to cook for another 15 minutes, adding stock or water if needed.

Serve the cacciucco not too dense, over toasted bread slices and rubbed with garlic.

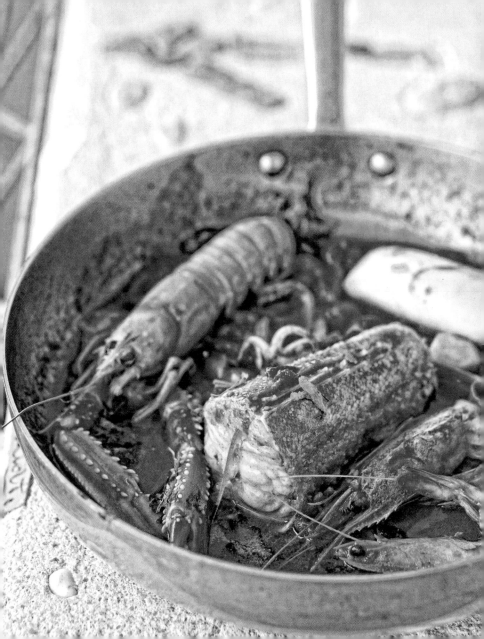

VEGETABLES AND SIDE DISHES

ZOLFINI BEANS IN NEW OIL WITH FRIED SAGE

Serves six
For the beans:
- 400 g (14 oz) of
 dried Pratomagno
 zolfini or other
 beans, as preferred
- 3 cloves of garlic
- 4–5 sage leaves
- extra virgin olive oil
- salt
- pepper
For the fried sage:
- 12 largish sage
 leaves
- flour
- extra virgin olive oil
- salt

How to prepare the beans
Rinse the beans well and leave to soak
for an hour.

Place in a pan, preferably earthenware or steel
with a thick insulated base, and add water for
5 times the weight of the beans. Add salt and
a whole garlic clove, the sage and a few tbsps
of oil.

Cover and simmer for about 2 hours, but
do not bring to the boil.

Serve hot, in the cooking juices, with salt,
pepper and newlypressed olive oil.

How to prepare the fried sage
Wash the sage and while still damp, dredge
in the flour.

Heat sufficient oil in a skillet and fry the leaves
for a few minutes, then place on a sheet of
kitchen paper to absorb the grease; add salt.

Garnish each plate of beans with crispy sage
leaves.

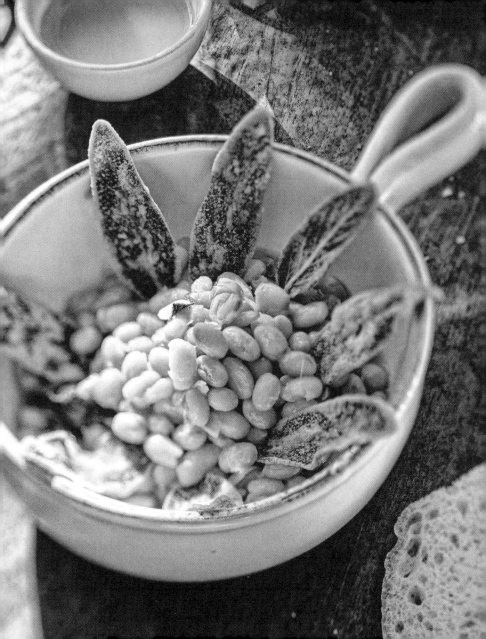

Serves four
- 8 artichokes
- 100 g (4 oz)
 Rigatino flat
 pancetta
- 2 cloves of garlic
- 1 lemon
- 1 sprig of parsley
- 1 tbsp of grated
 cheese
- vegetable stock
- extra virgin olive oil
- salt
- pepper

ARTICHOKES UPRIGHT IN THE PAN

Trim off the artichoke tips to ²/₃ of the height and level off the stems so the artichokes are upright in the pan. Set aside the stalks. Wash the artichoke and place immediately in a bowl of cold water with lemon juice.

Peel the stalks and chop a third of each one with garlic, Rigatino and parsley; season with a pinch of salt and pepper, and cheese.

Remove the artichokes from the water and drain, then pound on the table to open the leaves.

Remove the chokes from the artichoke and fill each one with the chopped ingredients.

Stand upright in a pan, add the remaining stems, drizzle with a little oil and sauté for 5-6 minutes until they are brown.

Add a ladle of hot broth, cover and leave to simmer gently for at least half an hour, until the bottom of the artichoke is very tender. If necessary, add other broth.

Push a stalk into each heart and serve warm.

FAUX SHEPHERD'S TRIPE

■■◻

Serves four
- 400 g (14 oz)
 of Pecorino
 or Parmigiano
 crust
- 500 g (1 lb) tinned
 tomatoes
- 2 mediumsized
 golden onions
- 1 tbsp of chopped
 parsley
- a pinch of ground
 chilli pepper
- 1 glass of white
 wine
- extra virgin olive
 oil
- salt
- pepper

Clean and scrape the cheese rinds and leave to boil for an hour (if possible in minestrone).

Cut 0.5 cm ($^1/_{10}$") slices of onion, brown in a little olive oil, salt lightly, add the chilli and deglaze with white wine.

Add the pureed tinned tomatoes and cook for 20 minutes, add the parsley and season with salt and pepper.

When the rinds are swollen and soft, drain and slice into strips of 1 cm ($^2/_5$") so it resembles tripe.

Pour the onion sauce into soup dishes and arrange the slices of the rind, sprinkling with parsley and drizzling with oil.

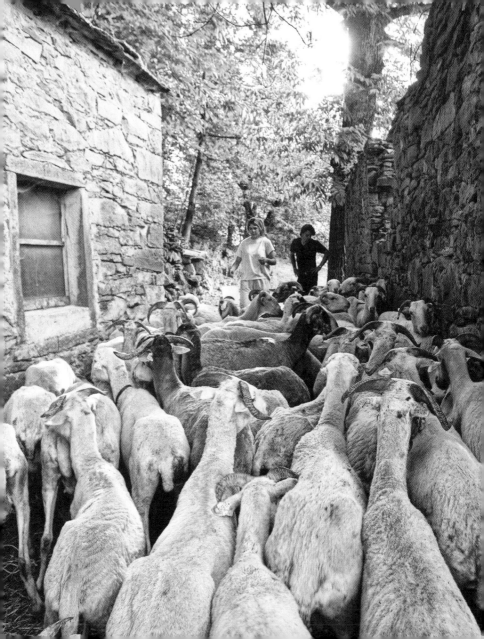

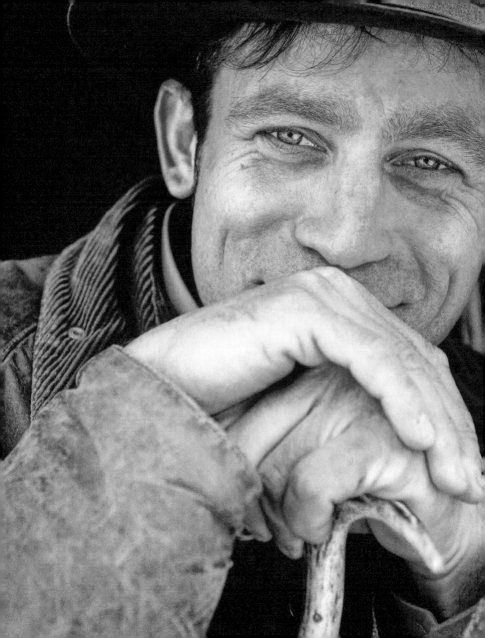

STUFFED RED ONIONS

■ ■ ☐

Serves four
- 4 red onions
- 1 egg
- 1 Tuscan sausage
- 100 g (4 oz) of
 minced (ground)
 beef
- 1 clove of garlic
- 1 sprig of parsley
- a handful of
 mature grated
 cheese (Pecorino
 or caciotta)
- breadcrumbs
- salt
- pepper

Peel the onions, removing the first skin
and cut away a 1 cm ($^2/_5$") horizontal slice;
cook for 5 minutes in boiling salted water,
drain and set aside.

Mix the two meats in a bowl, add chopped
garlic and parsley, a pinch of breadcrumbs,
the cheese, egg yolk, salt and pepper.

Scoop out the contents of the onions,
chopped finely and add to the mixture.

Whisk the egg white to peaks and fold
upwards into the mixture.

Fill the onions and arrange in an oven tray,
drizzle with oil, and bake at 180 °C (355 °F)
for 20 minutes.

If preferred, serve with a tomato sauce,
either hot or cold.

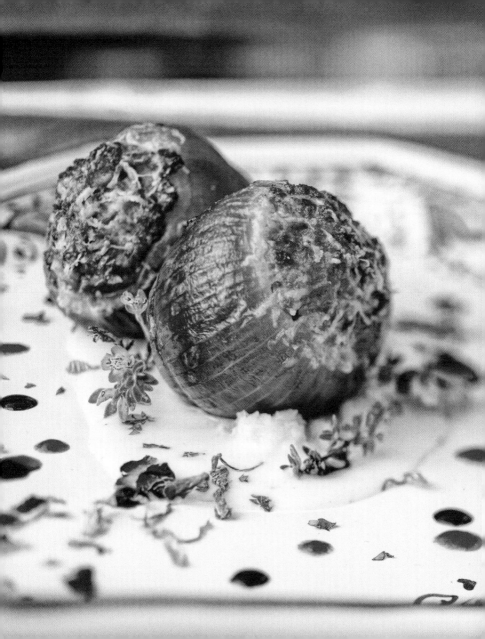

DESSERTS AND COOKIES

Serves four
- 300 g (10 oz)
 of flour
- 250 g (8 oz)
 unpeeled almonds
- 3 eggs
- 4 g (¹/₂ tsp) baking
 powder
- 250 g (1¹/₄ cup)
 of sugar
- salt

"CANTUCCI" ALMOND COOKIES

Sift the flour with the yeast and form a well on a pastry board. Add the sugar and a pinch of salt, then crack in the eggs; add the almonds.

Mix with a spatula, flour hands and divide the dough into small loaves.

Place the loaves on a baking tray lined with oven paper and bake at 175 °C (350 °F) for 15 minutes.

Remove from oven and allow to cool, then cut diagonally and place back in the oven for about 5 minutes until the cookies acquire their characteristic crispness.

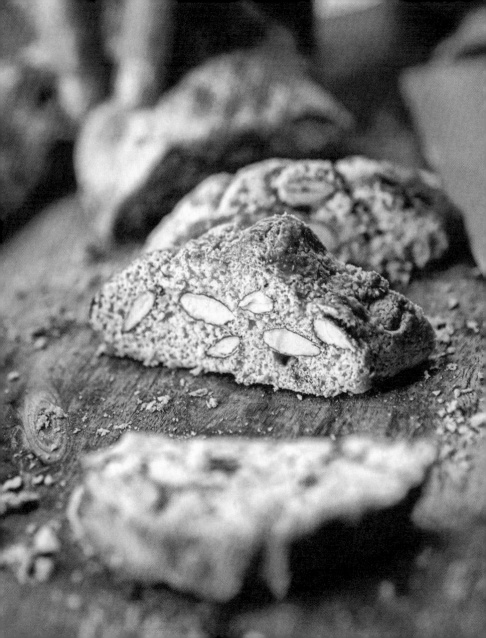

PRATO PEACHES

■ ■ ■

Serves four
- 350 g (3$\frac{1}{2}$ cups)
 of flour
- 1 egg
- 75 g (2$\frac{1}{2}$ oz) sugar
 + more for garnish
- 35 g (1$\frac{1}{4}$ oz) of
 butter
- 15 g ($\frac{1}{2}$ oz) of dry
 yeast
- zest of 1 lemon
- alkermes
- salt

*For the confectioners'
custard:*
- 0.5 l (1 pint) milk
- 70 g ($\frac{3}{4}$ cup) of
 flour
- 4 egg yolks
- 120 g ($\frac{2}{3}$ cup)
 of sugar
- $\frac{1}{2}$ a vanilla pod

Make a well with the flour and add salt and sugar. Pour the egg into the well and add the lemon zest, melted butter and the yeast dissolved in 180 ml (6 fl. oz) of lukewarm water. Knead for 10 minutes until the dough is smooth, without lumps and not too firm, cover and leave to rise for 2 hours.

Form balls with size of an egg and arrange well apart on a baking tray covered with greaseproof paper; leave to rise for an hour.

Bake at 160 °C (320 °F) for 30 minutes, then leave to cool.

Cut in half and quickly soak in a mixture of equal amounts of water and alkermes, then arrange in the sugar.

Fill with confectioner's custard so they resemble peaches.

How to make confectioner's custard

Boil the milk with 1 tsp of sugar and the seeds of half a vanilla pod.

Meanwhile, beat the egg yolks with sugar and flour, add 1 small ladleful of milk and continue whisking, preferably with an electric mixer, until the mixture is very smooth, lump free and fluffy.

When the milk reaches boiling point, remove the pod and drizzle into the mixture while whisking. Return to the pan and place on a slow heat until the mixture boils. As the cream thickens, whisk vigorously to avoid lumps forming.

Pour into a container and before storing in the refrigerator, cover the surface with baking paper that has been dampened and squeezed.

ZUCCOTTO

■ ■ ■

Serves four
- 250 g (9 oz) sponge cake
- 400 g (14 oz) of ricotta
- 250 g (1 cup) of fresh cream
- 50 g (2 oz) candied cherries and citron
- 100 g (4 oz) dark chocolate
- 1 tsp bitter cocoa
- 100 g ($^{1}/_{2}$ cup) of sugar
- 150 g ($^{3}/_{4}$ cup) of icing sugar
- 1 glass of cognac or brandy
- 2 small glasses of sweet liqueur (Grand Marnier, maraschino, kirsch, rum)

Whip the cream and add the icing sugar. Sieve the ricotta, add sugar and mix with the cream.

Divide the mixture into two portions and in the larger of the two mix the chopped candied peel and pieces of chocolate; in the other mix in the cocoa powder.

Trim the crust and edges of the sponge cake and then cut horizontally into two discs of 1 cm ($^{2}/_{5}$") in height. Cut a small disc to line the bottom of a plastic zuccotto mold (1.5 l/3 pints in capacity) and several long rectangles that will be used to line the sides of the container.

Dampen the slices with a brush dipped in the 2–3 mixed liqueurs and diluted with a little water.

Cover the sponge with a layer of chocolate cream, then fill the mold with the remaining cream and cover with another liqueursoaked sponge disc.

Press carefully with a disc of greaseproof paper and refrigerate for 5 hours, bearing in mind that real zuccotto is a not ice cream but a kind of parfait.

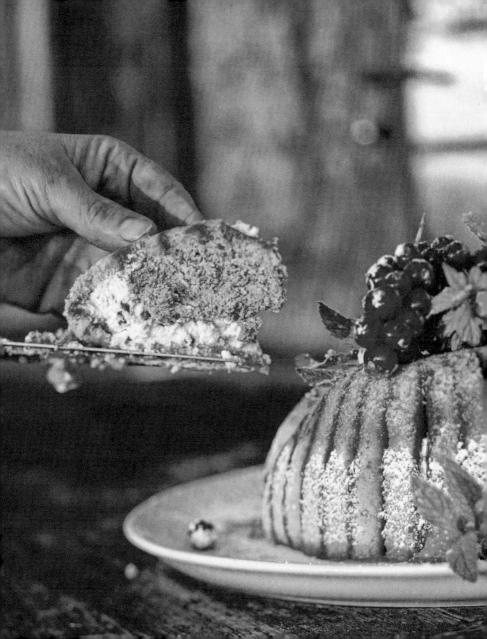

CASENTINO BAKED MILK PUDDING

Serves six
- 1 l (2 pints) of fresh fullfat milk
- 6 eggs
- 6 tbsps of sugar
- lemon zest and/ coffee beans to taste
- Vin Santo to taste

Heat the milk with lemon zest or 1 tsp of coffee beans (or both) to boiling point, then leave to cool.

In a bowl whisk the eggs with the sugar and the Vin Santo.

Pour the cooled, filtered milk into the cream of eggs and sugar, then mix well.

Pour the mixture into a baking dish or a more traditional earthenware pot (in both cases the height must be at least equal to 4 fingers).

Bake for an hour in a bain marie with the oven preheated to 160 °C (320 °F). While cooking ensure it does not colour too much, otherwise cover with a sheet of tin foil. Check for doneness with a toothpick which should come out dry.

Leave to cool at room temperature before serving. Can be stored for 3 days in a refrigerator and is also good served cold.

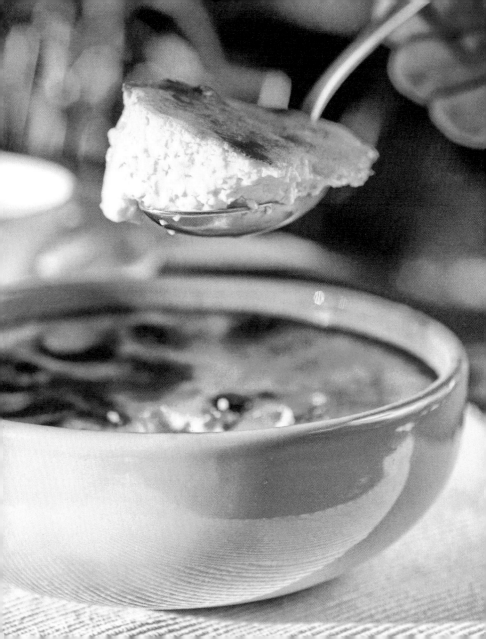

"CASTAGNACCIO" WITH RICOTTA MOUSSE

■ ■ ◻

Serves six
- 500 g (5 cups) of sieved chestnut flour
- 70 g (2½ oz) soaked raisins
- 50 g (2 oz) shelled walnuts
- 30 g (1 oz) of pine nuts
- a few rosemary leaves
- 300 g (10 oz) of ricotta
- extra virgin olive oil
- 2 tbsps of sugar
- 1 tbsp of icing sugar
- 1 tsp of salt

In a large bowl mix the flour with a cup of cold water to make a smooth mixture without lumps, then add more water until it reaches average density (about 500 ml/1 pint of water).

Add sugar, 3 tbsps of oil, salt, squeezed and dried raisins; mix well.

Thoroughly oil a rectangular baking sheet at least 2 cm (1") in height, then pour in the mixture, sprinkle the surface with pine nuts, chopped walnuts and rosemary.

Bake for 20 minutes or so in an oven preheated to 180 °C (355 °F).

Meanwhile, sieve the ricotta then add the icing sugar and a whisk until frothy.

Serve the castagnaccio while still warm, cut into slices and garnished with peaks of ricotta mousse.

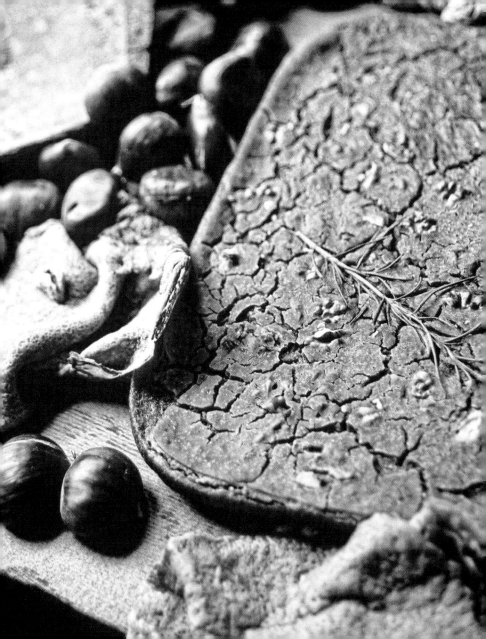

SIENA RICCIARELLI

■ ■ ■

Ingredients for 1 kg
(2lbs)
A.
- 300 g (1½ cups)
 granulated sugar
- 400 g (3 cups)
 peeled almonds,
 baked at 50 °C (120
 °F) for 10 minutes
- 50 g (½ cup) of flour
- 15 g (1 tbsp) candied
 orange peel
- (or the grated zest
 of 4 oranges)
- 5 ml (1 tsp) almond
 essence

B.
- 47 g (¼ cup) of
 granulated sugar
- 14 g (3 tsp) water

A.
Pulverize the almonds with the sugar in a food
processor using the blade attachment, then
add the flour mixed with the orange. Use the
pulse button to mix in short bursts to prevent
the almonds losing their oils. Add the almond
essence and put the mixture in a large bowl.

B.
In a small saucepan boil the sugar and water
to 108 °C (225 °F), then turn the heat off and
set the pan aside.

C.
Sift the flour; add the sugar, baking powder
and ammonia, and mix well.

Mix A, B and C together: the dough will stay
quite moist but not compact. Cover with
kitchen film so it does not dry out too much
and leave for 12 hours.

D.
Beat the egg whites until fluffy. Add the
vanillaflavoured icing sugar to the dough and
knead, then work in the egg whites until the
mixture is compact.

C.
- 20 g ($^1/_4$ cup)
 of flour
- 20 g ($^1/_4$ cup)
 of icing sugar
- 8 g ($^1/_4$ oz)
 of cake yeast
- pinch of baker's
 ammonia

D.
- 80 g (3 tbsp)
 egg whites
- 20 g ($^1/_4$ cup) of
 vanilla-flavoured
 icing sugar
- vanillaflavoured
 icing sugar
- corn starch

Dust the work surface with corn starch and vanilla-flavoured icing sugar (ratio 1:5). Shape individual sausage shapes of about 4.5 cm (1$^1/_2$ in) and cut into 1 cm ($^2/_5$") each (25-30 g or 1 oz in weight). Shape each roll by hand into a softly rounded diamond shape.

Dust the ricciarelli on the work surface covered with icing sugar and corn starch, and the tops only with icing sugar.

Place the ricciarelli on a baking tray lined with baking paper. Preheat the oven to 140 °C (285 °F) and bake the ricciarelli for about 20 minutes. They are done when they have formed slight cracks on the surface, but are still white and soft.

Remove from the oven and place delicately on a wire rack or a wooden chopping board so they dry.

Keep in an airtight container, at least until the next day, then serve.

PANFORTE

■ ■ ▢

Serves six
- 500 g (1 lb) of
 peeled almonds
- 300 g (3 cups)
 of flour
- 1 level tsp of
 powdered cinnamon
- a pinch of
 powdered cloves
- a pinch of nutmeg
- 300 g (10 oz)
 chopped
 candied citron
- 300 g (10 oz)
 chopped candied
 orange
- 300 g (1½ cups)
 icing sugar + more
 for garnish
- 300 g (10 oz)
 of acacia honey
- wafer

Toast the almonds lightly in the oven or
in a non-stick skillet.

In a bowl mix flour, spices, almonds, and
candied peel.

In a small pan, dissolve the icing sugar with
the honey on a medium heat. As soon as the
mixture starts to boil, add a small cup of cold
water, stir well and turn off heat. While still
hot, stir quickly into the flour mixture.

Line the bottom of 2 hinged molds with the
wafer and pour in the mixture. Press down
carefully to remove air bubbles, using a
weight.

Bake at 220 °C (430 °F) for 5 minutes, then
lower the temperature to 160 °C (320 °F) for
15 minutes. When cooked, unmold immediately
and sprinkle with plenty of icing sugar.

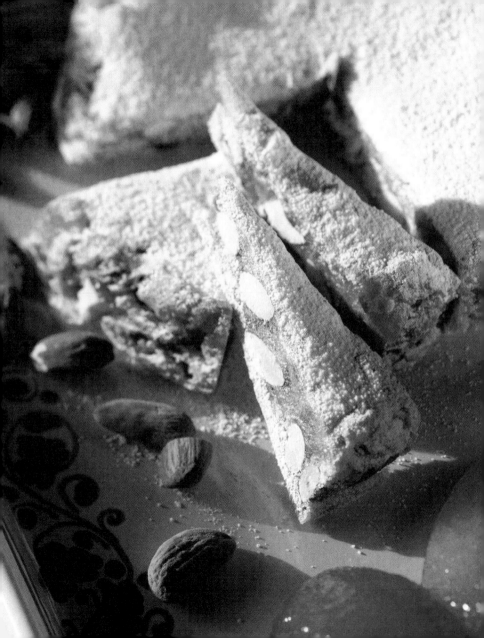

GLOSSARY

Acquacotta
Typical Maremma soup with numerous variations, made with stale bread, vegetables, mushrooms, eggs, and oil.

Cacciucco
Livorno-style fish dish, made with different kinds of seafood, stewed in tomato sauce, served on slices of toasted bread.

Cantucci
Cookies also called "biscotti di Prato," made from flour, almonds and eggs, with a characteristic elongated shape achieved by cutting the dough diagonally.

Cecigliano
Soup made from chickpeas, beans, chestnuts, and sweet corn.

Cecina
Another name for "farinata," chickpea flour pizza.

Chianina
Native cattle breed of central Italy, typical of the Val di Chiana.

Fettunta
Literally the "greasy slice," the typical Tuscan bruschetta of toasted bread, garlic and olive oil.

Lampredotto
Typical Florentine street food, a sandwich filled with seasoned beef tripe.

Lattaiolo
An aromatized milk pudding.

Panforte
A typical Siena cake made from flour, almonds, honey and candied fruit aromas, once called "pampepato."

Panzanella
A dish made of crumbled stale bread, tomatoes, onion, cucumber, oil, and vinegar.

Pici
Pasta typical of southern Tuscany, made from flour and water, with a bigger diameter than traditional spaghetti.

Pulezze
The local name for fresh turnip greens.

Ribollita
Soup made from stale bread, vegetables (black cabbage, beans), and oil.

Ricciarelli
Typical Siena cookies made with almonds, sugar, candied peel and egg whites. They are diamond-shaped, with a wrinkled surface dusted with icing sugar.

Rigatino
A kind of pancetta.

INDEX OF RECIPES

Tuscookany

To discover the true taste of Tuscany, we traveled to the three *Tuscookany* villas: Here food lovers from around the world gather to perfect the art of cooking Italian.

Torre del Tartufo ("Tower of Truffles"), an 16th century hill-top villa nested in Italy's truffle country near the Etruscan village of Arezzo is one of three impressive stone villas belonging to *Tuscookany*, which transformed the landmark properties into venues for deluxe cooking vacations.

Tuscookany's 17th century Casa Ombuto, on 80 magnificent acres, is a few miles from Poppi, one of the most beautiful villages in Italy. The contemporary Bellorcia villa in the Orcia Valley, neighbors Cetona. Among its many awards, Tuscookany was named by *The Observer* as one of the "Top ten cookery schools in Europe". At these luxurious accommodations, small groups of participants are instructed by some of the most respected Italian chefs in the region.

Tuscookany which was founded 1999 selects their chef-instructors as much for their superior culinary abilities as their enjoyment of teaching. Like all great chefs, they learned to cook in their mother's and grandmother's – and in some cases their great grandmother's, kitchens. The rustic dishes use simple, fresh ingredients. This is slow-cooked, richly flavored fare that draws seasonally from the garden, pasture and fields. At a long farmhouse table set beneath an awning of flowering vines participants share the dishes they've prepared.

www.tuscookany.com

Recipes by
Paola Baccetti, Laura Giusti,
Franco Palandra (Tuscookany)
Editing
William Dello Russo
Translation
Angela Arnone
Photoeditor
Giovanni Simeone
Design
Jenny Biffis
Prepress
Fabio Mascanzoni

Cover and dish images are by **Colin Dutton**,
except:
Stefano Amantini p. 11, **Massimo Borchi** p. 68
Matteo Carassale p. 19, p. 69, **Stefano Cellai** p. 91
Tim Mannakee p. 32, **Maurizio Rellini** p. 2-3
Massimo Ripani p. 10, p. 83, **Stefano Scatà** p. 33,
p. 43, p. 59, p. 61, **Luigi Vaccarella** p. 41
Philippe Vandenbroeck p. 6

Photos available on **www.simephoto.com**

This book is an excerpt of:

"TOSCANA IN CUCINA
THE FLAVOURS OF TUSCANY"

80 ricette della tradizione (e non)
80 traditional and non-traditional recipes

Recipes by Paola Baccetti, Laura Giusti,
Franco Palandra
Photographs by Colin Dutton

Hardback
Italiano/English
288 pages
19,5 x 23,5 cm
ISBN 978-88-95218-45-8

Distributed by Atiesse Rappresentanze
T. +39 091 6143954
www.simebooks.com